八段錦

Ba Duan Jin

冷先鋒 馬昌華 編著
Leng Xianfeng Sam Ma CheongWah Author

甘鳳群 示範
Gan Fengqun demonstrate

YouTube 學習八段锦 優酷學習八段锦

《國際武術大講堂系列教學》
編委會名單

冷先鋒簡介

　　江西修水人，香港世界武術大賽發起人，當代太極拳名家、全國武術太極拳冠軍、香港全港公開太極拳錦標賽冠軍、香港優秀人才，現代體育經紀人，自幼習武，師從太極拳發源地中國河南省陳家溝第十代正宗傳人、國家非物質文化遺產傳承人、國際太極拳大師陳世通大師，以及中國國家武術隊總教練、太極王子、世界太極拳冠軍王二平大師。

　　中國武術段位六段、國家武術套路、散打裁判員、高級教練員，國家武術段位指導員、考評員，擅長陳式、楊式、吳式、武式、孫式太極拳和太極劍、太極推手等。在參加國際、國內大型的武術比賽中獲得金牌三十多枚，其學生弟子也在各項比賽中獲得金牌四百多枚，弟子遍及世界各地。

　　二零零八年被香港特區政府作為"香港優秀人才"引進香港，事蹟已編入《中國太極名人詞典》、《精武百傑》、《深圳名人錄》、《香港優秀人才》；《深圳特區報》、《東方日報》、《都市日報》、《頭條日報》、《文彙報》、《香港01》、《星島日報》、《印尼千島日報》、《國際日報》、《SOUTH METRO》、《明報週刊》、《星洲日報》、《馬來西亞大馬日報》等多次報導；《中央電視臺》、《深圳電視臺》、《廣東電視臺》、《香港無線 TVB 翡翠臺》、《日本電視臺》、《香港電臺》、《香港商臺》、《香港新城財經臺》多家媒體電視爭相報導，並被美國、英國、新加坡、馬來西亞、澳大利亞、日本、印尼等國際幾十家團體機構聘為榮譽顧問、總教練。

　　冷先鋒老師出版發行了一系列傳統和競賽套路中英文 DVD 教學片，最新《八法五步》、《陳式太極拳》、《長拳》、《五步拳》、《陳式太極劍》、《陳式太

極扇》、《太極刀》、《健身氣功八段錦》、《五禽戲》等中英文教材書，長期從事專業的武術太極拳教學，旨在推廣中國傳統武術文化，讓武術太極拳在全世界發揚光大。

　　冷先鋒老師本著"天下武林一家親"的理念，以弘揚中華優秀文化為宗旨，讓中國太極拳成為世界體育運動為願景，以向世界傳播中國傳統文化為使命，搭建一個集文化、 健康與愛為一體的世界武術合作共贏平臺，以平臺模式運營，走產融結合模式，創太極文化產業標杆為使命，讓世界各國武術組織共同積極參與，達到在傳承中創新、在創新中共享、在共用中發揚。為此，冷先鋒老師於 2018 年發起舉辦香港世界武術大賽，至今已成功舉辦兩屆，盛況空前。

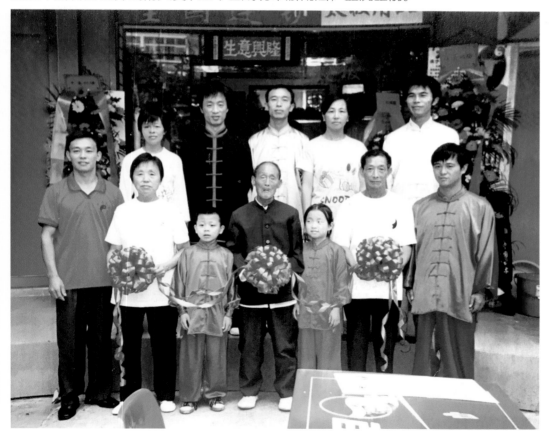

太極世家　　四代同堂

Profile of Master Leng Xianfeng

Originally from Xiushui, Jiangxi province, Master Leng is the promoter of the Hong Kong World Martial Arts Competition, a renowned contemporary master of taijiquan, National Martial Arts Taijiquan Champion, Hong Kong Open Taijiquan Champion, and person of outstanding talent in Hong Kong. A modern sports agent, Master Leng has been a student of martial arts since childhood, he is a 11th generation direct descendant in the lineage of Chenjiagou, Henan province – the home of taijiquan, and inheritor and transmitter of Intangible National Cultural Heritage. Master Leng is a student of International Taiji Master Chen Shitong and Taiji Prince, Master Wang Erping, head coach of the Chinese National Martial Arts Team and World Taiji Champion.

Master Leng, level six in the Chinese Wushu Duanwei System, is a referee, senior coach and examiner at national level. Master Leng is accomplished in Chen, Yang, Wu, Wu Hao and Sun styles of taijiquan and taiji sword and push-hands techniques. Master Leng has participated in a series of international and prominent domestic taijiquan competitions in taiji sword. Master Leng has won more than 30 championships and gold medals, and his students have won more than 400 gold medals and other awards in various team and individual competitions. Master Leng has followers throughout the world.

In 2008, Master Leng was acknowledged as a person of outstanding talent in Hong Kong . His deeds have been recorded in a variety of magazines and social media. Master Leng has been retained as

an honorary consultant and head coach by dozens of international organizations in the United States, Britain, Singapore, Malaysia, Australia, Japan, Indonesia and other countries.

Master Leng has published a series of tutorials for traditional competition routines on DVD and in books, the latest including "Eight methods and five steps", "Chen-style taijiquan", "Changquan", "Five-step Fist" and "Chen-style Taijijian","Chen-style Taijishan","Taijidao", "Health Qigong Baduanjin","Wuqinxi".Master Leng has long been engaged as a professional teacher of taijiquan, with the aim of promoting traditional Chinese martial arts to enable taijiquan to spread throughout the world.

Master Leng teaches in the spirit of "a world martial arts family", with the goal of "spreading Chinese traditional culture, and achieving a world-wide family of taijiquan." He promotes China's outstanding culture with the vision of "making taijiquan a popular sport throughout the world". As such, Master Leng has set out to to build an international business platform that promotes culture, health and love across the world of martial arts practitioners to achieve mutual cooperation and integrated production and so set a benchmark for the taiji culture industry. Let martial arts organizations throughout the world participate actively, achieve innovation in heritage, share in innovation, and promote in sharing! To this end, Master Leng initiated the Hong Kong World Martial Arts Competition in 2018 and has so far successfully held two events, with unprecedented grandeur.

馬昌華醫師的個人資料

馬昌華醫師是英國執業中醫針灸醫師，在英國居住了 40 多年。他也是健身氣功和太極拳的教練及裁判，他也英國皇家空軍的前成員。

馬醫師在 10 歲時就開始了中國，日本和韓國風格的武術之旅，包括少林，螳螂，洪拳，蔡李佛，詠春，柔道，柔術，合氣道，跆拳道，楊式和孫式太極拳。

他跟隨太極及形意大師葉志威和太極宗師李德印教授的女兒李暉學習太極拳和健身氣功。李德印教授是北京中國人民大學的著名人物也是孫式第四代傳人及楊家 24 式最具權威人士。

馬醫師也是氣功和太極拳比賽教練，曾經協助運動員在英國國內和國際比賽中獲得多項金牌，銀牌和銅牌獎狀。 他還是中醫藥教學研討會的講師和演講者，以提高人們對健康管理的認識。

Dr. Sam Ma Profile

Dr. Sam Ma BSc LicAc, has been living in England for over 40 years. Sam is a Chinese Medicine Acupuncturist, Health Qigong and Taijiquan instructor and judge. He is a former member of the British Royal Air Force.

Sam started his martial arts journey at the age of 10 on Chinese, Japanese and Korean styles including Shaolin, Praying Mantis, Hung Ga, Choi Lei Fut, Wing Chun, Judo, Jujitsu, Aikido, Taekwondo, Yang and Sun style Tai chi.

He studies Taijiquan and Health Qigong with masters Tary Yip and Faye Yip whose father is the famous professor Li Deyin who is leading figure at People's University of China in Beijing,Sun style 4th generation and Yang style 24 steps highest authority.

Sam has been coaching Qigong and Taijiquan competitors to achieve various gold, silver and bronze medals in both UK national and international competitions. He is also a lecturer and speaker in seminars teaching Chinese Medicine to bring awareness to health management.

甘鳳群簡介

　　甘鳳群，中國武術六段，國家二級社會體育指導員，國際武術裁判員，國際武術教練，府內派太極拳一脈第九代弟子，楊式太極拳一脈第八代弟子，武當玄武派三豐自然宗第十七代弟子。多次參加過國際、國內、省、市各級健身氣功比賽並多次獲獎：

　　2016 年榮獲廣東省健身氣功站點聯賽《八段錦》一等獎

　　2017 年榮獲首屆沙巴亞太區大極精英大匯演健身氣功《導引養生功十二法》二等獎，

　　2017 年榮獲首屆廣東健身氣功藝術表演大賽銀獎

　　2018 年榮獲全國百城千村健身氣功《大舞》《導引養生功十二法》兩項金牌

　　2018 年榮獲江門市健身氣功站點聯賽《易筋經》第一名

　　2019 年榮獲第 17 屆香港國際武術節個人健身氣功第一名

　　2020 年榮獲首屆中英健身氣功《八段錦》一等獎

　　2019 年參加廣東省健身氣功巡迴教學活動，培訓和帶領隊伍參加各種健身氣功比賽並取得優異成績。

Gan Fengqun Profile

　　Gan Fengqun, has the honor to win the sixth section of Chinese martial arts, the social sports instructor of national second class, the international Wushu referee, the international martial arts coach, the ninth generation of Funei-Style Tai Chi Quan, the eighth generation of Yang-Style Tai Chi Quan, the 17th generation of Sanfeng natural sect of Wudang XuanwuStyle. She has participated in the international, domestic, provincial and municipal Fitness Qigong competitions for many times and won many awards.

　　She won the first prize of "eight section brocade" in Guangdong Fitness Qigong League Match in 2016.

　　Won the second prize of " Guide Health 12 Methods " in first Sabah Asia Pacific elite grand gathering in Fitness Qigong in 2017.

　　Won the Silver medal of the first Guangdong Fitness Qigong art performance competition in 2017.

　　Won two gold medals of "Big Dance" and "Guide Health 12 Methods " in the National Hundred Cities Gan Village Health Qigong in 2018.

　　Won first place "Yijin Jing" in Jiangmen Fitness Qigong League Match in 2018.

　　Won the first place of personal Fitness Qigong in 17th Hong Kong International Wushu Festival in 2019.Won the first prize of "eight section brocade" in first Chinese and British Fitness Qigong in 2020.

　　She participated in teaching activites of Fitness Qigong tour in Guangdong Province. She trained and led the teams to participate in various Fitness Qigong competitions, and achieved excellent results.

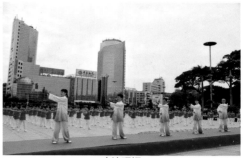

大賽啟動儀式　　　　　　　　　　　　表演現場

獲獎證書

獲獎證書

獲獎證書

獲獎證書

獲獎證書

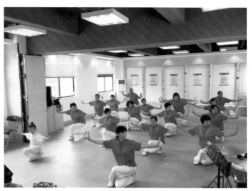

2019 廣東省健身氣功巡回教學活動　　　　　　　　教學現場

第二屆"太極羊"香港世界武術大賽頒獎

慶七一，健身氣功站點聯賽　　　　　　　　　　頒獎盛典

2017 年首屆廣東省氣功藝術表演大賽　　　　　　　　　　領獎現場

比賽現場　　　　　　　　　　　　　　　　　　領獎現場

比賽現場

 冷先鋒太極（武術）館

中華武術

火熱招生中......

地址：深圳市羅湖區紅嶺中路1048號東方商業廣場一樓、三樓

電話：13143449091　　13352912626

【名家薈萃】

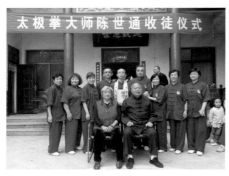

陳世通收徒儀式

王二平老師

趙海鑫、張梅瑛老師

武打明星梁小龍老師

王西安老師

陳正雷老師

余功保老師

林秋萍老師

門惠豐老師

張山老師

高佳敏老師

蘇韌峰老師

李德印教授

錢源澤老師

張志俊老師

曾乃梁老師

郭良老師

陳照森老師

張龍老師

陳軍團老師

【名家薈萃】

劉敬儒老師

白文祥老師

張大勇老師

陳小旺老師

李俊峰老師

戈春艷老師

李德印教授

馬春喜、劉善民老師

丁杰老師

付清泉老師

馬虹老師

李文欽老師

朱天才老師

李傑主席

陳道雲老師

馮秀芳老師

陳思坦老師

趙長軍老師

【獲獎榮譽】

【電視采訪】

【電臺訪問】

【合作加盟】

【媒體報道】

【培訓瞬間】

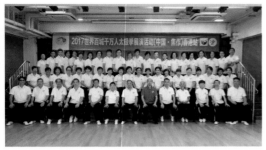
百城千萬人太極拳展演活動

雅加達培訓

汕頭培訓

王二平深圳培訓

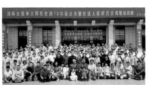
師父70大壽

香港公開大學培訓

印度尼西亞培訓

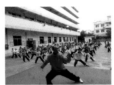
松崗培訓

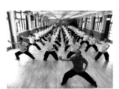
香港荃灣培訓

王二平深圳培訓

陳軍團香港講學

印尼泗水培訓

油天培訓

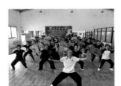
印尼扇培訓

七星灣培訓

陳軍團香港講學培訓

油天培訓

美國學生

馬春喜香港培訓班

【賽事舉辦】

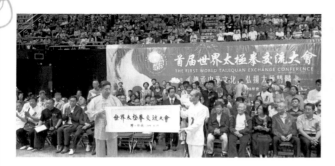

首屆世界太極拳交流大會

第二屆"太極羊杯"香港世界武術大賽

第二屆"太極羊杯"大賽

日本德島國際太極拳交流大會

首屆世界太極拳交流大會

馬來西亞武術大賽

東莞擂臺表演賽

首屆永城市太極拳邀請賽

首屆永城市太極拳邀請賽

2018首屆香港太極錦標賽

2019首屆永城市太極拳邀請賽

【專賣店】

八 段 錦
Ba Duan Jin

目 錄
DIRECTORY

● 掌 Palm

五指微直而帶鬆，意存指尖，掌心微收

Finger straight but relax, intention on fingertips, center of palm slight concave

● 八字掌 L shape palm

拇指及食指豎直成八等形，其余三指扣緊，力達掌根

Thumb and index finger keep straight to form L shape, other fingers hook in, focus on base of the palm

● 扣弦手 Hook finger palm

五指於第一關節內扣

Distal and Middle Phalanx (except Thumb) of all fingers hook in

● 拳（握固）Fist posture

大拇指抵掐無名指根節內側，其余四指屈攏收於掌心。

Pinch your thumb to the bottom of the inner ring finger, and bend the other four fingers close to the center of your palm.

代表右手右腳路線

代表左手左腳路線

八段錦
Ba Duan Jin

● 並步 Opening stance

雙腳合拼，雙手直垂，頸項向上微伸，正視

Feet close together, arms straight down by the side, head and neck slightly stretch up, gaze forward

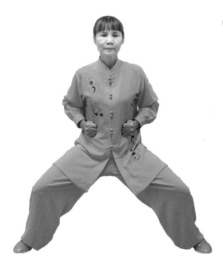

● 四平馬步 Horse stance

雙腳距約肩膊兩倍闊，腳尖向前，膝與腳尖同一直線，屈膝下坐 至大腿與地面平，尾骨向前微兜

Feet apart double the width of the shoulders, toe point to front, knee and toe in line , flex knee to sit to thigh parallel to floor with tailbone tilting forward.

預備式
Ready position

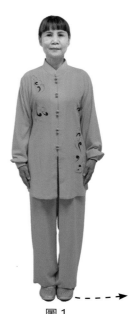

1. 虛領頂勁 Crown of head slightly lift up

2. 㖞頂上顎 Tongue touch palate (roof of mouth)

3. 含胸拔背 Relax shoulders to embrace chest

4. 垂尾閭 Tilt tailbone forward

5. 十趾微扣地 Toes lightly grip floor

圖 1

● 動作循序 Movement flow

1. 雙腳並步自然直立, 兩臂放鬆垂於體側, 中指尖向地, 身體中正, 目視前方。
【圖 1】

1.Naturally stand straight with feet together, relax arms hanging down to the side of your body with middle finger tip pointing to floor, centralise body and look straight ahead。 【Fig1】

預備式
Ready position

2. 入定片刻，調息 3 次

calm mind for a while，regulate breathing 3 times

3. 隨著鬆腰沉髖，重心移至右側，左腳向橫開步，腳尖朝前，與肩同寬，目視前方。【圖 1-2】

Then loosen up waist and sinking hips, shift body weight to right, and the left foot moves to the side, shoulder width apart with the toes facing forward, looking straight ahead。【Fig2】

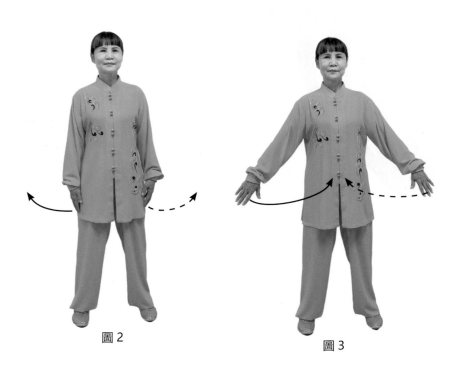

圖 2　　　　　　　　圖 3

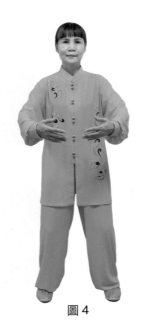

圖 4

4. 兩臂鬆肘微後內旋，掌心向後，兩掌分別向兩側擺起，兩臂外旋。 【圖 3】
Relax elbows, palms face back with arm rotating inwardly and slightly backward, then arms rotate outward and elevate palms to the side as if trying to hold something。 【Fig 3】

5. 兩腿膝關節微鬆，骶骨下沉下坐，兜尾閭，同時提升兩臂及外旋，向前合抱於肚臍前呈圓弧形如抱大球或大酒埕，兩掌指間距約一橫掌闊，目視前方。【圖 4】
Relax both knees, sink sacrum as sitting with tailbone tilt forward, simultaneously lifting arms and rotate laterally, gradually to front, centre of palms level with naval, both arms curve round in an arc shape like hugging a gigantic bal. Look straight ahead。 【Fig 4】

6. 入定片刻，調息 6 次
Calm mind for a while, regulate breathing 6 times

預備式
Ready position

● **動作要點**

1. 頭向上頂，下頦微收，舌抵上齶，雙唇輕閉；沉肩墜肘，腋下虛空，胸部寬舒，腹部鬆沉；收髖斂臀，上體中正。

2. 呼吸徐緩，出入於鼻，氣沉丹田

● **Key points**

Keep your crown suspended, chin tuck in slightly, the tongue touch upper palate with lips lightly closed; keep shoulders and elbows relax and sink down, armpits empty lightly away from body, open chest, relax the abdomen, tighten but relax hips and uplift buttocks with intent, centralise and align upper body.

Breath slowly, in and out through nose, descend Qi below navel into the *Dantian

● **易犯錯誤及糾正方法**

X 抱球時，大拇指上翹，其餘四指斜向地。

✔沉肩，垂肘，指尖相對，大拇指放平。

X 塌腰，跪腿，八或入字腳。

✔收髖斂臀，命門穴放鬆，下坐上體時，膝關節不超越腳尖，兩腳平行站立，腳趾向正前方。

X When holding the ball, thumb is up and other four fingers are pointing towards the ground.

✔ Keep the shoulders and elbows down, the fingertips pointing at each others at thumb level.

X Buttocks sticking out, knees bending too much, toes pointing outward or inward.

✔ Tighten but relax hips and lifting buttocks, relax at the *Ming Men point, knees do not go over the toes when lower the body, and stand with feet parallel to each other, toes pointing ahead.

● 功理與作用

守靜心神，調整呼吸，內安五臟，端正身形，從精神與肢體上做好練功前的準備。

● Benefits

Keep calm, adjust your breathing, calm your five internal Yin organs, adjust posture , prepare mental and physical readiness to perform the routine.

備注
丹田

肚臍一橫掌下，又名關元穴，是任脈上主穴之一。

命門

腰椎第二節與第三節中間，又名命門穴，是督脈上主穴之一。

Reference
Dian tian

Palm width directly below navel, Ren 4, one of the important acupuncture points on Ren channel.

Ming men

Between lumbar vertebrae 2 and 3, Du 4, one of the important acupuncture points on Du channel.

第一式：两手托天理三焦

First move : Both hands push sky regulate San Jiao (Triple Burner)

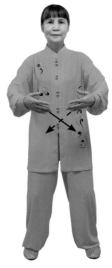

圖 1.1

◉ **動作循序 Movement flow**

1. 尾閭微下坐，身體中正，十趾微扣地。
1.Lower tailbone, body upright, toes slightly engaging to floor.

2. 兩臂下落至丹田，前臂微外旋，掌心朝上。【圖 1.1】
2.Arms gradually rotate outward and descend to Dan Tian, then palms face up.(Fig 1.1)

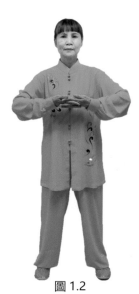

圖 1.2

3. 八指交插於丹田前。兩腿慢慢挺膝伸直，雙掌提升至胸前 * 膻中穴。【圖 1.2】
3.Fingers interlock at Dan Tian, raise body till knees straight with both palms raise to * Ren17. (Fig 1.2)

第一式：两手托天理三焦
First move : Both hands push sky regulate San Jiao (Triple Burner)

4. 兩臂內旋，掌心反轉朝上，隨著兩臂向上提升至 *
太陽穴旁，目視掌背。【圖 1.3】

4.Rotate palms face up, eyes gaze at dorsal of palms, raise arms to temple region, Tai Yang point. (Fig 1.3)

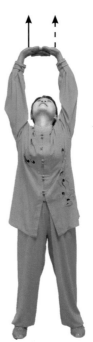

圖 1.3

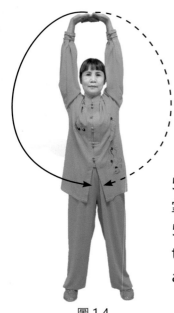

5. 接著目視前方，下頦內收，上臂移至耳旁，手掌根部向上伸展，手肘關節伸直不鎖。【圖 1.4】

5.Eyes look forward, chin in, moves arms next to ears, base of palms push upward to extend arms without locking elbows. (Fig 1.4)

圖 1.4

第一式：兩手托天理三焦

First move : Both hands push sky regulate San Jiao (Triple Burner)

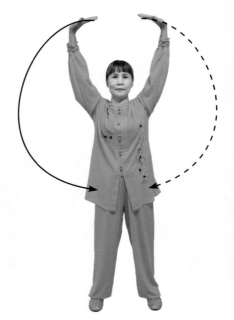

6. 隨後雙掌分開，同時沉肩墜肘，手腕放鬆，雙臂分別在身旁弧形緩慢下降。【圖 1.5】

6.Then separate palms, relax shoulders, elbows then wrist, arms descend gradually on side of body as a curve.(Fig 1.5)

圖 1.5

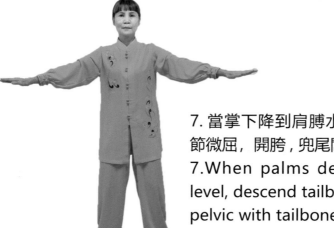

7. 當掌下降到肩膊水平，重心下沉，膝關節微屈，開胯，兜尾閭。【圖 1.6】

7.When palms descend to shoulder level, descend tailbone, flex knees open pelvic with tailbone tuck in. (Fig 1.6)

圖 1.6

第一式：两手托天理三焦

First move : Both hands push sky regulate San Jiao (Triple Burner)

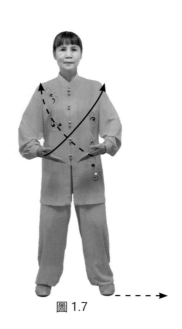

圖 1.7

8. 隨後兩臂外旋呈弧形合抱前方於＊神闕穴前，目視前方。【圖 1.7】

8.Rotate arms, embrace palms in front of *Ren 8, eyes ahead. (Fig 1.7)

9. 重複 3-8。

9.Repeat moves from 3-8.

第一式：两手托天理三焦

First move : Both hands push sky regulate San Jiao (Triple Burner)

- 次數

 動作雙掌上托及下落為一循環，共做六循環。

- Repetition

 Movement on palms up down as 1 cycle, total 6 cycles is required.

- 動作要點

 以手帶身起，雙掌上托時，腹有空洞感、上臂及腋下雙側有拉伸感。

- Key points

 Lift crown to raise body, abdominal region has emptiness sensation, upper arm and Teres Major muscle feels stretching.

- 易犯錯誤及糾正方法

 X 上托時，雙臂鎖肘及意不在掌根。

 ✔ 上托時，雙臂伸展保持肘鬆，意存掌根。

- Common mistakes and correction

 X locking elbows and focus not on base (on) palms when push to sky.

 ✔ extend both arms with elbows relax, focus on base of palms when push to sky.

- 功理與作用

 雙手上托帶氣，以伸拉胸腹令 * 三焦 暢通，氣血調和。

- Benefits

 Palms leading the Qi upward, stretching and compressing *San Jaio (Triple Burner) to energise abdominal organs.

第一式：两手托天理三焦

First move : Both hands push sky regulate San Jiao (Triple Burner)

● 備注

膻中穴 - 胸部位置，前正中線上，兩乳頭連線的中点，第四胸骨與正中線的交叉點。

太陽穴

前額兩側，外眼角延長線的上方。 在兩眉梢後凹陷處。

神闕穴

肚臍。

三　焦

六腑之一，主通五臟六腑水道。分上、中、下焦。上焦：橫膈膜以上，中焦：橫膈膜至肚臍（神闕穴），下焦：肚臍以下。

● Reference

Dan Zhong (Ren 17)

On the anterior midline, at the level with the fourth intercostal space, midway between the nipples.

Tai Yang

In the depression about one finger breadth posterior to the midpoint between the lateral end of the eyebrow and the outer canthus.

Shen Que (Ren 8)

In the center of the umbilicus.

San Jaio (Triple Burner, TB)

It is Traditional Chinese Medicine concept where TB is the name given to three interrelated areas of the body, the upper, middle and lower Jiao. To subdivide the region, Upper TB: above diaphragm, Middle TB: between diaphragm and navel, Lower TB : below navel.

第二式：左右開弓似射鵰
Second move : Left Right open bow shoot eagle

● **動作循序 Movement flow**

1. 續上式，身微下坐，重心右移，左腳向側開一大步。

1.From last move, lower body and shift weight to right, step wide to left.

2. 雙膝自然伸直站立，雙掌心向內交疊於 * 膻中穴 前，左掌疊右掌，目視前方。【圖 2.1】

2.Stand up loosely with knees straight, cross palms in front of *Dan Zhong (Ren17) with left over right, eyes front. (Fig 2.1)

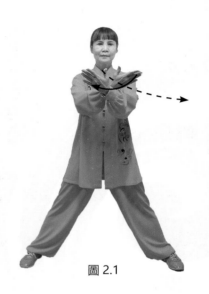

圖 2.1

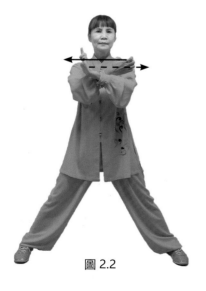

圖 2.2

3. 左掌的拇指和食指直豎成中國八字掌，右掌手指屈曲成扣弦手，雙掌心放鬆。【圖 2.2】

3.Stretch left thumb and index finger as letter L and hook the rest 3 fingers, hook right thumbs and fingers as pulling string, middle of both palms feel "empty". (Fig 2.2)

第二式：左右開弓似射鵰
Second move : Left Right open bow shoot eagle

4. 緩慢骶骨下坐成大馬步，同時左八字掌外旋掌心推向左側，（食指向天），意存掌根，左食指向天，頭及視線隨左食指；右扣弦手的肘向右直線推出至 * 雲門穴 前，雙臂與肩同高及向左右雙方成 170 度對拉伸展，同時氣聚丹田，馬步下坐，如同開弓射箭的姿勢，身體保持中正，目光定於左食指。【圖 2.3】

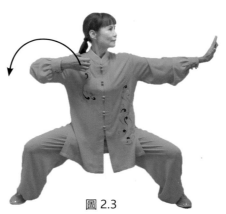

圖 2.3

4.Sink Sacrum to form wide horse stance, rotate left palm using base of palm push to left with index finger pointing up as "L shape palm", head and eyes follow index finger to turn and look to the left; elbow of right arm with "hook fingers palm" push to the right with wrist reaching in front of *Yun Men (LU2), both left palm and right elbow level up to shoulder height, spanning to 170 degrees stretching opposite direction. Sink Qi into DanTian, lower horse stance as opening bow to shoot, centralise body, eye fixed on left index finger. (Fig 2.3)

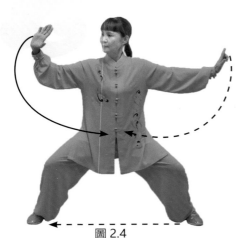

圖 2.4

5. 重心移右，左腳微內扣，右扣弦手成掌劃弧向右上方伸出，掌心向右。 【圖 2.4】

5.Shift weight to right, hook left toe in slightly, relax right fingers into full palm drawing curve stretching to right top corner, palm facing right.(Fig 2.4)

第二式：左右開弓似射鵰
Second move : Left Right open bow shoot eagle

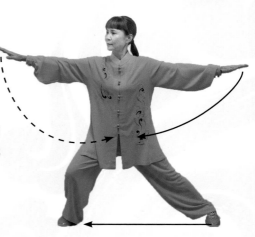

6. 左手成掌，掌心向左，雙臂與肩同高。
【圖 2.5】
6.Left hand forms palm facing left, both forearms same level as shoulders.(Fig 2.5)

圖 2.5

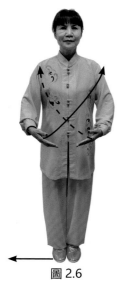

7. 左腳尖微向地推，收回成（并）立步站立；雙掌分別下按收回肚臍前，掌心向上。【圖 2.6】
7.Left toes push off the ground to bring both feet together as standing position. Both palms circle down from both sides to the front of the navel, palms up.(Fig 2.6)

圖 2.6

8. 隨後重心左移，右腳向側開一大步。
8.Then, shift weight to left and step wide to right.
9. 雙膝自然伸直站立，雙掌心向內交疊於膻中前，右掌疊左掌，目視前方。【圖 2.7】
9.Stand up loosely with knees straight, cross palms in front of Dan Zhong (Ren17) with right over left, eyes front.(Fig 2.7)

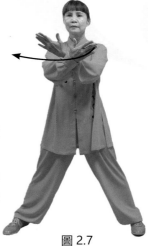

圖 2.7

第二式：左右開弓似射鵰

Second move : Left Right open bow shoot eagle

10. 與動作 次序 3 至 6 相同，惟獨左右相反方向。
10.Repeat move from step 3 to 6 with left right swap over.

11. 在最後循環收右腳時，應與肩同寬。
11.At the last move, bring the right foot in with shoulder width apart.

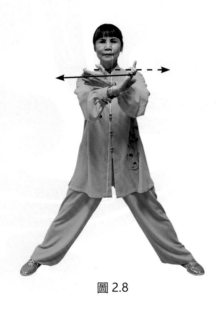

圖 2.8

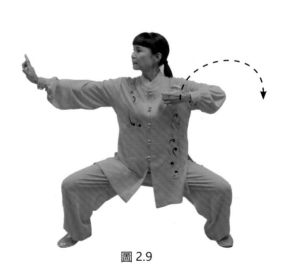

圖 2.9

第二式：左右開弓似射鵰
Second move : Left Right open bow shoot eagle

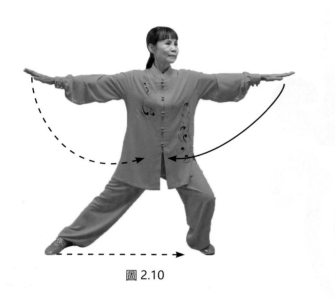

圖 2.10

圖 2.11

- **次數**

 左右開弓動作為一循環，共做三循環。

- **Repetition**

 Left right open bow movement as 1 cycle, total 3 cycles is required.

- **動作要點**

 掌與肘伸展而不僵硬，坐馬低，身體中正，開馬步要保持平衡。

- **Key points**

 Palm and elbow stretch oppositely firm but not tensed, horse stance low, centralise body, maintain balance with step aside

第二式：左右開弓似射鵰

Second move : Left Right open bow shoot eagle

● **易犯錯誤及糾正方法**

X 八字掌食指向前，壓縮胛骨，鎖肘。

✔八字掌食指向天，伸展胛骨，臂直但鬆肘。

● **Common mistakes and correction**

X Index finger of Letter L palm point forward, compress scapulas, lock elbows.

✔ Index finger of Letter L palm point to sky, stretch scapulas, straight arms but relax elbows.

● **功理與作用**

開胸擴肺以助調肺及腎氣，鍛煉腿部肌肉，刺激手三陰經在腕上的原穴。

● **Benefits**

Expand and open the chest to allow the lungs and kidney Qi to communicate, strengthen quadriceps muscles, stimulate source points on 3 Yin channels at the wrist.

備注

膻中穴

在身前中线，與第四肋間隙齊平，或在乳頭之間的中點。

雲門穴

位於人體胸前壁的外上方，肩胛骨喙突上方，鎖骨下窩凹陷處。

Reference

Dan Zhong (Ren 17)

On the anterior midline, level with the 4th intercostal space, or at the midpoint between the nipples.

Yun Men (LU2)

On the upper lateral chest , superior to the coracoid process of the scapula, in the depression of the infraclavicular fossa.

第三式：調理脾胃須單舉
Third move : Regulate Spleen and Stomach with single lift

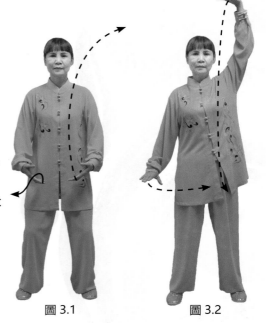

圖 3.1 圖 3.2

動作循序 Movement flow

1.續上式,雙掌收於丹田前,掌心朝上。
【圖 3.1】

1.From last move, right palm in front of Dantain facing up. (Fig 3.1)

2. 左臂內旋於身前上升, 指尖朝上, 掌心向左, 穿經膻中及臉部, 達至前額, 兩腿挺膝伸直 ; 左臂外旋上至頭正上方, 掌心向上, 同時, 右掌反掌向下 在丹田前側; 雙掌力存掌根, 左掌繼續向上托, 左指尖向右在 *肩井穴 之上; 右掌向下按, 右指尖向前位與髖旁, 雙掌上下對拉伸展, 目視正前方 。
【圖 3.2】

2. left forearm rotates inward raise through front of body, pass Danzhong to face to reach forehead, both knees gradually straighten up；Left arm rotates outward to above head with palm facing up, right palm facing down in front of Dantain；Focus on base of both palms, left palm pushes up, finger tips point right and directly above *JianJing (GB21); right palm pushes down to side of pelvic, fingertips point front; both palms stretch oppositely, eyes front.【Fig 3.2】

第三式：調理脾胃須單舉

Third move : Regulate Spleen and Stomach with single lift

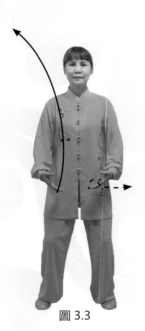

圖 3.3

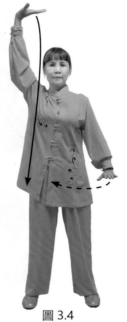

圖 3.4

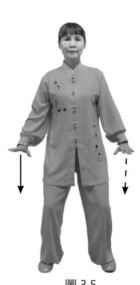

圖 3.5

3. 接著放鬆腰胯，重心緩慢下沉，兩腿關節微屈，同時鬆左肘，左臂外旋，左掌經過臉部及膻中下降至腹前，掌心向上；右臂內旋掌心向上，雙掌同時捧於腹前指尖相對，目視前方。【圖 3.3】

3.Relax and descend pelvic, knees slightly flex, relax left elbow and rotate arm outward to descend palm down through face, Dan Zhong to Dan Tian, palm face up; right palm rotate inward with palm face-up, both palms meet at Dan Tian, tips pointing to each other.(Fig 3.3)

4. 重覆動作 1-4，左右方向相反。

4.Repeat move from 1-4, with left right swap over.

5. 在最後循環，右手下落，骶骨下坐微屈膝，雙掌下按於髖旁，指尖向前，目視前方。【圖 3.4】

5.At the end of the last cycle, lower right arm, sink sacrum flex knees, place both palms by the side of the pelvic with fingers pointing forward, eyes front.(Fig 3.4)

第三式：調理脾胃須單舉

Third move : Regulate Spleen and Stomach with single lift

◉ **次數**：雙掌上下伸拉為一循環，共做三循環。

◉ **Repetition**：Palms push up and down as 1 cycle, total 3 cycles is required.

◉ **動作要點**

雙掌對拉到極點時，上舉手腰側，上臂，膽經及三焦有伸拉感，大包穴 的開啟

◉ **Key points**

When both palms push oppositely fully, the raised upper arm, Gall Bladder meridian and SanJiao should feel stretching and * Dabao (SP21) opening

◉ **易犯錯誤及糾正方法**

X 對伸拉時，鎖肘，閉氣

✔ 直但鬆肘，呼氣

◉ **Common mistakes and correction**

X When palms push oppositely and fully, lock elbows, hold breathe

✔ Straight but loose elbow, exhale

◉ **功理與作用**

雙掌對拉以伸展脾、胃、肝、膽經及三焦部位，刺激膽汁分泌以提升消化系統功能

◉ **Benefits**

Palms push oppositely to stretch a Spleen, Stomach, Liver and Gall Bladder meridian and open Dabao point.

備註：**大包穴**

在胸部外側，在腋中線上，在第六肋間隙。

Reference：**Dabao (SP21)**

On the lateral aspect of the chest, on the mid-axillary line, in the 6th intercostal space.

第四式：五勞七傷往後瞧

Fourth move : Five exhaustion seven injuries look behind

動作循序 Movement flow

1. 續上式，掌心朝下力存掌根，雙掌在身旁兩髖向下微伸展。【圖 4.1】

1.From last move, palms face down, focus on root of palm, place by both side of pelvic strength down slightly. (Fig 4.1)

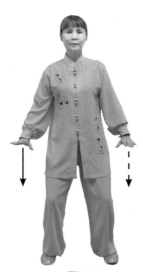

圖 4.1

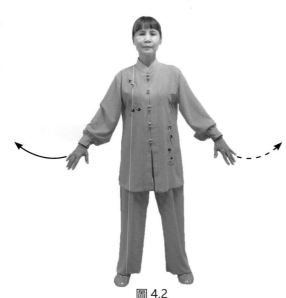

圖 4.2

2. 雙膝緩慢伸直，兩臂微內旋，掌心朝後。【圖 4.2】

2.Raise body with knees straight, slightly rotate arms inwards with palms face back.(Fig 4.2)

第四式：五勞七傷往後瞧

Fourth move : Five exhaustion seven injuries look behind

3. 指尖朝下，雙臂上提至與身體成 30 度，臂及掌心向外旋至掌外側朝天，雙臂及食指向地方向伸展，頭部同時也從正前方緩慢轉向左方。

3. Fingertips stretch pointing 30 degree downward away from body, rotate arms and palms outwards till lateral side of palm up, arms stretch towards floor led by index fingers, turn head gently to look left.

4. 下巴微收，鼻尖在肩膊尖線上，眼珠盡向（右）左後方看，微壓縮雙胛骨即放鬆。 【圖 4.3】

4. Chin in, nose in line with left shoulder tip, roll eyeball to left outer canthus, slightly bring scapulas together by compressing rhomboid muscles then relax.(Fig 4.3)

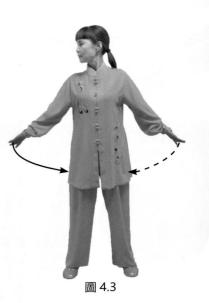

圖 4.3

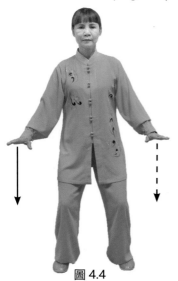

5. 隨後雙掌內旋停於髖旁，頭及眼正視前方。 【圖 4.4】

5. Rotate palms to the side of the pelvic, head straight and eyes look ahead.(Fig 4.4)

6. 重覆動作 1-5，左右方向相反。

6. Repeat above 1- 5, with right side swap over.

圖 4.4

第四式：五勞七傷往後瞧

Fourth move : Five exhaustion seven injuries look behind

7. 在最後循環，雙掌收回到丹田前，掌心向上，指尖相對，骶骨下坐微屈膝，目視前方。【圖 4.5-4.6】

7.At the end of the last cycle, palms face up, fingertips pointing to each other, placed in front of Dantian, sit on tailbone, flex knees, look ahead.(Fig 4.5-4.6)

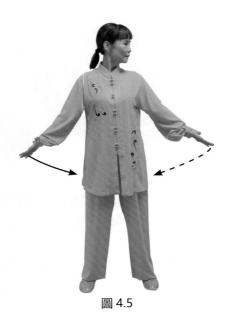

圖 4.5

圖 4.6

次數

雙臂及掌外旋，轉頭，壓胛骨，眼球向後看為一循環，共做三循環。

Repetition

Arms and palms rotate outwards, turn head, compress scapulas and eye ball roll to outer canthus as 1 cycle, total 3 cycles is required.

第四式：五勞七傷往後瞧

Fourth move : Five exhaustion seven injuries look behind

動作要點

臂伸展及掌向外轉時應感覺肘及肩的開啟，眼珠向眼外角望時有微拉感，大小菱形及斜方肌在胸背部有壓縮伸展感。

Key points

Arm stretch down and palm rotate to feel elbows and shoulders open, eyeballs feel slightly stretched to either side of the outer canthus, rhomboid, trapezius muscles feel compressed and relax at the thoracic region.

易犯錯誤及糾正方法

X 上身及頭向後仰，臂向後帶動過多，胛骨壓伸不足或過長久，臂及掌伸展及旋轉不足，手指屈曲。

✔上身及頭伸正，頭轉位到於肩頂上線，用肩膊壓縮胛骨，以指帶臂伸展及旋轉。

Common mistakes and correction

X Upper body and head lean too far back, arms over swing toward back, compressing scapulas not enough or too long, fingers curls up, arms and palms not stretch and rotate insufficiently.

✔ Head lift up and never lean back, arms at side of body never pass the body line, just a little "squeeze" on scapulas then relax to feel compressed and relaxed.

功理與作用

1. 五勞者，心勞神損，肺勞氣損，脾勞食損，肝勞血損，腎勞損精。

2. 七傷者，喜、怒、悲、憂、恐、驚、思七情傷害；心為主神，神定七情定；肺為主氣，氣足勞減。

3. 本動作伸展旋轉手少陰心經以達通心氣運行通暢，強心安神。

4. 壓縮胛骨以刺激 背俞穴的 * 肺俞，* 心俞，* 膏肓俞，達至增氣，舒神及治虛勞。

5. 轉頭及眼球以刺激 * 大椎穴及頸後肌肉，增強陽氣運行及頸部血液循環以減勞損及平七情。

第四式：五勞七傷往後瞧
Fourth move : Five exhaustion seven injuries look behind

Benefits

1.Exhausted Heart damages spirit, exhausted Lungs damage Qi, exhausted Spleen damages appetites, exhausted Liver damages blood, exhausted Kidneys damage bodily essence.

2.Emotional overwhelming disruption of body and mind functioning, Heart nourishes Spirit to stabilise emotion; Lungs governing Qi, Qi abundant, tiredness reduces.

3.Open Hand Shao Yin Heart Channel by stretching and rotating arms allowing Qi flow abundantly to increase Heart functions for calming mind and spirit.

4.Compress and relax scapulas to activate *BL13, *BL15 and *BL43 to boost Qi, immune system and soothe Heart nourishes spirit.

5.Turn head and roll eye ball to one side activating *DU14 and Trapezius muscle to elevate Yang Qi and increase neck blood to nourish the brain.

備注

肺俞穴： 位於背部，當第 3 胸椎棘突下，旁開 1.5 寸。

心俞穴： 位於背部，當第 5 胸椎棘突下，旁開 1.5 寸。

膏肓俞穴： 位於背部，當第 4 胸椎棘突下，旁開 3 寸。

大椎穴： 位于背部，第 7 頸椎棘突下。

Reference

BL13： 1.5 cun lateral to the lower border of the spinous process of the 3rd thoracic vertebra.

BL15： 1.5 cun lateral to the lower border of the spinous process of the 5th thoracic vertebra.

BL43： 3 cun lateral to the lower border of the spinous process of the 4th thoracic vertebra.

DU14： 1.5 at the lower border of the spinous process of the 7th cervical vertebra.

第五式：搖頭擺尾去心火
Fifth move : Swing head sway tail rid heart fire

動作循序 Movement flow

1. 续上式，身體重心向左移，右腳向側開一大步，同時兩掌向上托至膻中前。【圖 5.1】

1.From the last move, shift body weight to the left leg, step wide to right with palms face up, lift up in front of REN17. (Fig 5.1)

圖 5.1

圖 5.2

2. 兩腿自然伸直，雙掌外旋，隨身直立而向上托，直至肩井穴上方，保持肘部微曲，掌尖相對，正視前方。【圖 5.2】

2.Naturally straighten legs, rotate palms out and push up above head in line with GB21, relax elbow, fingertips pointing to each other, look ahead.(Fig 5.2)

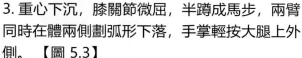

第五式：搖頭擺尾去心火
Fifth move : Swing head sway tail rid heart fire

3. 重心下沉，膝關節微屈，半蹲成馬步，兩臂同時在體兩側劃弧形下落，手掌輕按大腿上外側。【圖 5.3】

3.Descend sacral, flex knees to form horse stance, both arms descending in an arc shape to place on lateral quadriceps, palm lateral side slightly rotated out.(Fig 5.3)

圖 5.3

圖 5.4

4. 百會穴帶身微上升，重心向右移，上身向右傾，左腿伸直，右腿保持鬆膝，右側的頭頸腰腿漸成一直線，左肘微直。【圖 5.4】

4.Rise body led by lifting DU20, shift body weight to right, Upper body leans to right, left leg, body, neck and head formed straight line, left elbow pushed slightly straight.(Fig 5.4)

5. 隨後俯身，目定於右腳。【圖 5.5】

5.Then face body down, eyes fixed on the right foot.(Fig 5.5)

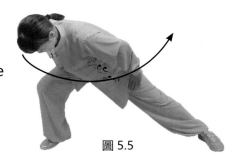

圖 5.5

第五式：搖頭擺尾去心火
Fifth move : Swing head sway tail rid heart fire

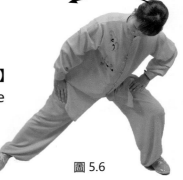

6. 上身及重心向左移 ， 目轉視右腳。【圖 5.6】
6. Sway the upper body gradually to the left, eyes then fix to the left foot.(Fig 5.6)

圖 5.6

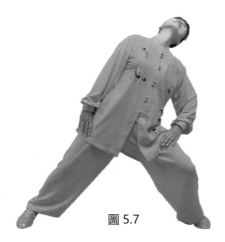

圖 5.7

7. 隨後目視（向）上方，頭微仰後放鬆。 【圖 5.7】
7.Then eyes to front, relax head and tip slightly back.(Fig 5.7)

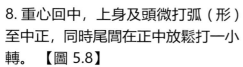

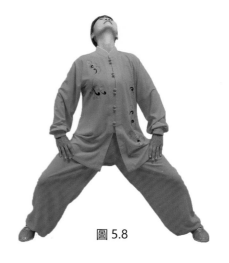

8. 重心回中，上身及頭微打弧（形）至中正，同時尾閭在正中放鬆打一小轉。 【圖 5.8】
8.Centralise body with head and upper body rotate slightly to centre, coccyx draw a small circle. (Fig 5.8)

圖 5.8

第五式：搖頭擺尾去心火
Fifth move : Swing head sway tail rid heart fire

9. 重心微上升後下降坐成馬步，目視前方。 【圖 5.9】
9.with body raise slightly and sit as horse stance, eyes front.(Fig 5.9)

圖 5.9

圖 5.10

圖 5.11

圖 5.12

圖 5.13

10. 重覆動作 1-6，左右方向相反。
10.Repeat above 1-6, with the other side swap over.

第五式：搖頭擺尾去心火
Fifth move : Swing head sway tail rid heart fire

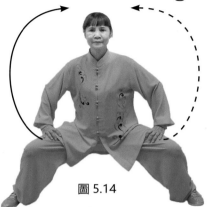

圖 5.14

11. 在最後循環，身體正中，收回右腳與肩同寬，成站立步身體直正，雙掌向外側劃弧帶至頭頂，掌心雙對，肘伸展向上，目視前方。隨後重心下沉，鬆膝下坐，同時雙掌沿身前下降至＊氣海穴 前，掌心向下。

圖 5.15

11.At the end of the last cycle,centralise the body, bring right foot in shoulder width apart, stand up straight, both palms draw arc raising above head, palm face to each other, stretch elbows, eyes forward, then sink sacral, flex knees, descend palms face down to front of *REN6.

圖 5.16

功理與作用
經常口腔潰瘍，喉嚨赤痛，眼白赤紅者常是心有虛火，中下焦普遍濕寒；這動作的下坐及擺尾將虛火下降與腎水相遇，達至水火相融。

Benefits
Frequent mouth ulcer, burning throat and blood shot eyes are the sign of deficiency heart heat raising up which is caused by damp cold stagnation in the abdominal area; this move using coccyx rotation with low stance to harmonise water and fire by invigorate kidney water for descending heart fire.

第五式：搖頭擺尾去心火
Fifth move : Swing head sway tail rid heart fire

5

● **次數**

上身左右搖擺動為一循環，共做三循環。

● **Repetition**

Upper body sway right to left and left to right as 1 cycle, total 3 cycles is required.

● **動作要點**

動作要緩慢漸進，尤是搖頭俯身，不應求快。

頸部與尾骨應成對拉，搖頭擺尾時以輕柔對轉，仿似身為軸首及尾為輪，互對運轉。

● **Key points**

Movement maintains slow and smooth, especially swing head and swing tail, do not move speedily.

Neck and sacral form an opposite pull, light and soft when rotating head and sacral, imagine the body is the axial, head and sacral are wheels, circulate in opposite directions.

● **易犯錯誤及糾正方法**

X 仰頭打轉幅度太大，尾閭打轉幅度太小。

✔放鬆頸部肌自由打轉，髖關節打轉輕鬆劃大圓。

● **Common mistakes and correction**

X Head rotation range too big causing cervical vertebrae damaged, Coccyx rotation too little.

✔ Relax neck muscle to rotate head naturally, sacral and coccyx rotation like drawing circle on floor.

X Body swaying during head and coccyx rotation, whole spine no stretching sensation.

✔ Maintain spin fully stretched during rotation.

第六式：兩手攀足固腎腰
Sixth move : Both palms reach feet strengthen kidneys

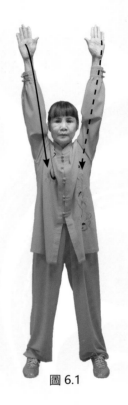

圖 6.1

動作循序 Movement flow

1. 续上式。身體上升直立及兩掌指尖向前伸展，兩臂上舉至耳旁，肘伸直，掌心相對，目視前方。【圖 6.1】

1. From the last move raise the body with fingers pointing and stretching forward, raise arms with elbows stretched up by ears facing each other, eyes front. (Fig 6.1)

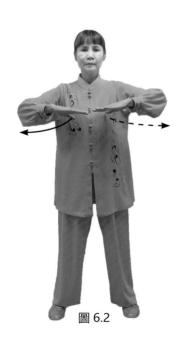

圖 6.2

2. 隨後掌心向下按至膻中前，指尖相對，目視前方。【圖 6.2】

2. Palms press down to front of Dan Zhong, point fingers together, eyes front. (Fig 6.2)

第六式：兩手攀足固腎腰
Sixth move : Both palms reach feet strengthen kidneys

3. 反掌至掌心向上，隨之雙掌尾指沿腋下＊大包穴 向後伸至掌心按到脊骨兩旁的背闊肌；目視前方。 【圖 6.3a, b, c】

3.Rotate palms up, then both fifth fingers slide along the rib under axilla through *SP21 to reach back muscle Latissimus Dorsi along both sides of the spine, eyes front.(Fig 6.3 a,b,c)

圖 6.3a

圖 6.3b

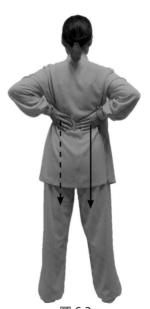

圖 6.3c

第六式：兩手攀足固腎腰

Sixth move : Both palms reach feet strengthen kidneys

4. 兩掌心輕按背闊肌沿下直達臀大肌，肘關節挺直。【圖 6.4】

4.Both palms with light pressure press on back muscle running down till reaching Gluteus Maximus with elbow straight.(Fig 6.4)

圖 6.4

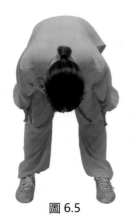

圖 6.5

5. 隨後上體向上伸展及向前俯，兩掌繼續沿腿後膀胱經向下擴運，巡行經 * 委中, * 承山兩穴。【圖 6.5】

5.Then upper body extend upward forward to fold downward, both palms keep running along back of legs pass through *BL40, *BL57.(Fig 6.5)

第六式：兩手攀足固腎腰
Sixth move : Both palms reach feet strengthen kidneys

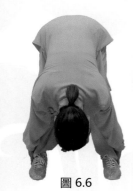

6. 達至腳踝外側的 * 昆崙穴，同時視向前下方。【圖 6.6】
6.Reaching *BL60, eyes downward forward.(Fig 6.6)

圖 6.6

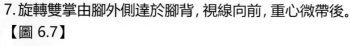

7. 旋轉雙掌由腳外側達於腳背，視線向前，重心微帶後。
【圖 6.7】
7.Bring palms round from lateral side to dorsal of feet,
eyes forward, weight shifts slightly back. (Fig 6.7)

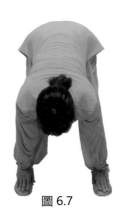

圖 6.7

8. 雙掌從腳背向前向上，雙臂伸直達耳旁，隨後由指
尖伸前微弧形帶上身起，重心微前，十趾按地。【圖 6.8】
8.Palms stretch forward upward till arms by ears
side with elbow straight, then upper body led by
fingers stretching forward and up with a little arc, toes
engaged to floor, weight slightly front. (Fig 6.8)

圖 6.8

第六式：兩手攀足固腎腰

Sixth move : Both palms reach feet strengthen kidneys

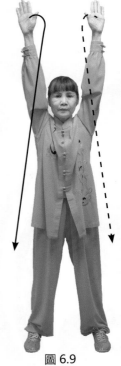

9. 雙臂繼續向前向上伸舉至全身挺直及腰微伸拉，掌心向前，正視。【圖 6.9】

9.Arms continuously stretch forward upward till full body upright with waist slightly stretched, palms and eyes front.(Fig 6.9)

圖 6.9

10. 重覆動作 2-9。

10.Repeat moves from 2-9.

11. 在最後循環，骶骨緩下沉，鬆膝，雙掌心下按至臗骨外側，指尖向前，正視。【圖 6.10】

11.At the last move, sink sacral flex knees, palms press down to side of pelvic, fingers point forward, eyes forward.(Fig 6.10)

圖 6.10

第六式：兩手攀足固腎腰
Sixth move : Both palms reach feet strengthen kidneys

- 次數

掌下落，俯身及挺直為一循環，共做六循環。

- Repetition

Palms down, fold the body and stretch up as 1 cycle, total 6 cycles.

- 動作要點

1. 掌按背闊肌力度適中及位置在上點較好，但肩要鬆沉。
2. 上身起立時，應指帶臂，臂帶身，首尾對伸拉而上。

- Key points

1.Palms press firmly on latissimus dorsi with relatively high position with shoulders relaxed.

2.Use fingers to lead arms and body up with spine fully stretched during the upper body coming up.

- 易犯錯誤及糾正方法

X 俯身時身體不挺直，低頭，膝關節彎曲。

✔上身保持挺直，視線向前，膝關節伸直。

X 起上身時，身帶手上，脊骨彎曲。

✔手帶身上，重心向前上方，首尾互對拉。

- Common mistakes and correction

X Body curl up when fold downwards, dip head and knees bend.

✔ Upper body maintains upright, eyes forward with knees straight.

X Body comes up before arms when raising up, slouching.

✔ Use arms to lead body up, weight slight forward with spine straight.

第六式：兩手攀足固腎腰
Sixth move : Both palms reach feet strengthen kidneys

● 功理與作用

1. 膀胱經為各臟腑的腧穴之處，以雙掌適量按壓背部各腧穴，明顯有提高臟腑功能。尤其腎臟在胸柱九至十一節，掌心＊勞宮穴 之氣能壯腎培元。

2. 俯身前盼伸展可刺激脊柱及＊督脈 以至引發陽氣提升。

● Benefits

1.Bladder channel contains relevant acupuncture corresponding to all internal organs, with light pressure massage those acupuncture points can energise their corresponding organ to improve functions. Kidney organs situate at between 9th and 11th thoracic vertebrae, the warmth from *PC8 point on the palm can strengthen the kidney Qi.

2.Activate the *DU channel by extending and stretching the upper body can invigorate Yang Qi.

● 備註

大包穴： 在第六肋間隙。

委中穴： 膝蓋後面的直線中間。

承山穴： 小腿後側肌肉浮起的尾端位置。

昆崙穴： 外足踝後方，踝尖和跟腱之間的凹陷處。

勞宮穴： 在手掌心，第三、四掌骨之間。

● Reference

SP21: On the middle axillary line, in the 6th intercostal space.

BL40: Midpoint of the transverse crease of the popliteal fossa.

BL57: In a pointed depression formed below the gastrocnemius muscle belly.

BL60: In the depression between the tip of the external malleolus and Achilles' tendon.

PC8: At the center of the palm, between the 2nd and 3rd metacarpal bone.

DU channel: one of the Eight extraordinary channels, located mostly on spine and is abundant with Yang Qi.

第七式：攢拳怒目增氣力

Seventh move : Gather fists with glare increase strength

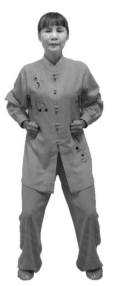

● **動作循序 Movement flow**

1. 续上式, 雙掌同時劃弧下落成 * 握固, 掌根按放於 * 期門穴 前, 目視前方。【圖 7.1】

1.From last move, lower arms as arch forming *"Qi gong fist", palms base rest at *LV14, eyes front.(Fig 7.1)

圖 7.1

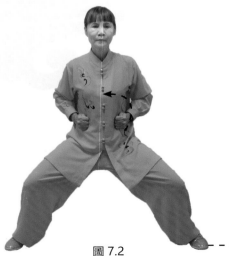

圖 7.2

2. 重心向右腳移, 左腳向橫開大步緩下坐成四平馬步。【圖 7.2】

2.shift body weight to right leg, left foot takes a wide side step, slowly forming horse stance.(Fig 7.2)

第七式: 攢拳怒目增氣力
Seventh move : Gather fists with glare increase strength

3. 左握固緩慢帶微力向前直線推出，目定母指怒視，至臂直肘鬆，與膻中穴同高。【圖 7.3】

3.Left qigong fist gradually extending forward push with gentle force, eyes gaze at left fist angrily till fully forward with elbow relax, fist levels with REN17.(Fig 7.3)

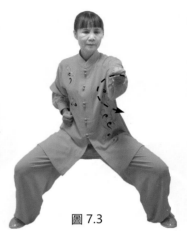

圖 7.3

4. 目不離左手，鬆左握固成掌，臂內旋至尾指向天，四指向手背挑上，前臂帶腕外旋至四指向天，向左，向下，向前，掌心向上而握固。【圖 7.4 a,b,c,d,e】

4.Eyes gaze at left fist continuously, left fist becomes palm, rotate forearm and wrist inwards till palm lateral side face up, rotating palm outwardly with wrist in full extension, palm up then form qigong fist.(Fig 7.4 a,b,c,d,e)

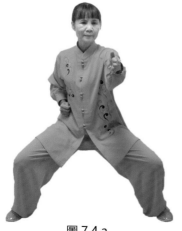

圖 7.4.a

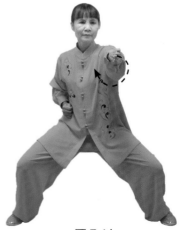

圖 7.4.b

68

第七式：攢拳怒目增氣力

Seventh move : Gather fists with glare increase strength

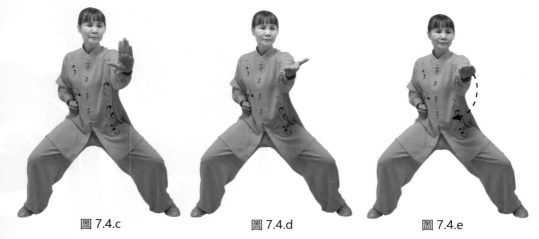

圖 7.4.c 圖 7.4.d 圖 7.4.e

5. 收左握固按回期門穴位，眼神收斂視前方。【圖 7.5】

5.Retract fist back to LV14 position, eyes soften up look front.(Fig 7.5)

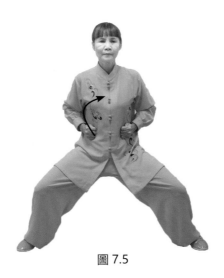

圖 7.5

第七式： 攢拳怒目增氣力

Seventh move : Gather fists with glare increase strength

6. 同動作二至五，右側相同。

6.Repeat moves 2-5, same for right side.

7. 在最後循環，收回左腳並步直立，雙掌自然下垂在體側，目視前方。【圖 7.8】

7.At the last move, bring the left foot in to stand up with close feet, both palms hang down naturally by the side of the body, eyes front.(Fig 7.8)

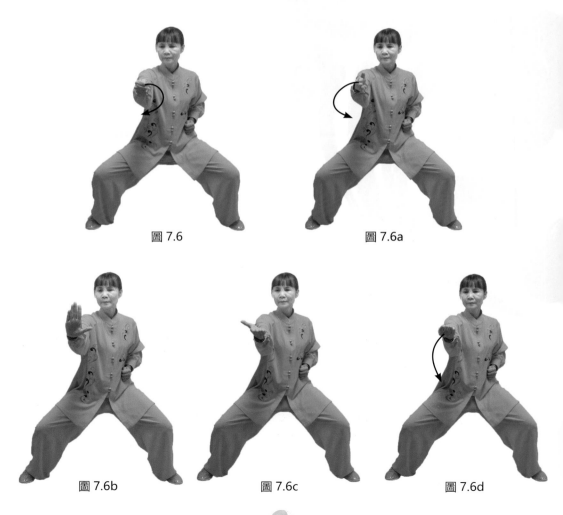

圖 7.6 圖 7.6a

圖 7.6b 圖 7.6c 圖 7.6d

第七式：攢拳怒目增氣力

Seventh move : Gather fists with glare increase strength

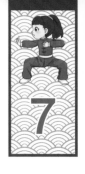

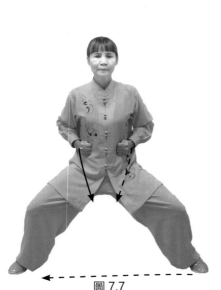

圖 7.7

圖 7.8

- **次數**

 動作左右推收握固為一循環，共做三循環。

- **Repetition**

 Movement push out and retract fist left and right as 1 cycle, total 3 cycles is required.

- **動作要點**

 1. 推出及收回握固時緊而不僵硬，要怒目而視，鬆腰沉肩。
 2. 收握固前，手腕充份旋轉，微擰腰。
 3. 呼吸自然，出握固時呼，收時吸。
 4. 馬步平穩用力抓地。

第七式： 攢拳怒目增氣力

Seventh move : Gather fists with glare increase strength

Key points

1. Qigong fist should be tight but not tense both push out and pull in, gaze with wild eyes open, loose waist and sink shoulder.

2. Maximum rotation on wrist before forming Qigong fist, slight rotate waist naturally.

3. Natural breathing, push out Qigong fist breath out and breath in when pulled in.

4. Horse stance with good balance and press firm on floor.

易犯錯誤及糾正方法

X 出及收握固時身體左搖右擺，過份扭腰，提肘升肩。

✔ 身體中正，虛領頂勁，沉肩墜肘。

X 出握固時閉及忍氣，過份用力，鎖肘，旋腕弧度太小及無力。

✔ 自然呼吸，出握固呼，入吸，柔柔用力，鬆肘，旋轉手腕弧度大，手指伸直。出及收握固時身體要中正。

Common mistakes and correction

X swaying body when pushing or retract Qigong fist, over twisting waist, raise elbow and shoulders.

✔ centralise body, crown suspended from heaven, sink elbows and shoulders.

X holding breathe when pushing Qigong fist out, use bull or too much force, lock elbows, very little wrist rotation or with no effort.

✔ natural breathing, Qigong fist out breath out, retract fist breath in, gentle force, relax elbows, maximise wrist rotation range with fingers fully stretched.

第七式：攢拳怒目增氣力

Seventh move : Gather fists with glare increase strength

● 功理與作用

1. 中醫理論的肝臟特性是"竅於目，發於筋，華在爪"。握固可強筋肌，怒目可刺激肝血以疏導肝氣，平衡全身氣機運行。

2. 四平馬可刺激腎氣以助肝氣，在五行理論中，水生木，腎為水，肝為木。

● Benefits

1.Chinese Medicine theory details the characteristic of the Liver organ, it's orifice is the eyes, released into the tendon and prosperous at the nails. Holding Qigong fist and glare can help energise Liver Qi to smooth flow for the whole body.

2.Horse stance can activate Kidney to promote Liver Qi, in Five Element theory, Water nourish Wood, Kidney is Water and Liver is Wood.

● 備注

握固：拇指按放環指根部，四指合攏 成虛拳。

期門穴：位于胸部，當乳头直下，第 6 肋間隙。

● Reference

Qigong fist: thumb fold at base of fourth finger then fingers fold over the thumb to hold a loose fist.

LV14: at the chest directly below the nipple, at the 6th intercostal muscle.

第八式 往後七顛百病消
Seventh move : Gather fists with glare increase strength

● **動作循序 Movement flow**

1. 续上式。下頷微收，頸上伸展，頭向上頂，兩腳跟不斷提起至頂點，十指向下伸，眼前望。【圖 8.1 a,b】

1.From the last move, chin in, stretch neck upward, crown of head push up, raise heels gradually to the maximum height, finger stretch down to floor, eyes front.(Fig 8.1 a,b)

圖 8.1a　　　圖 8.1b

2. 保持頭向上頂, 腳跟下落一半, 離地小許。【圖 8.2】

2.Maintain crown of head lifted up, lower heel half way down, keep little distance from floor.(Fig 8.2)

3. 唇微開，腳跟下落着地輕震，全身保持挺直，氣從口出。

3.Lips slightly open, heels gently hit floor to create slight impact, maintain body upright, exhale through mouth.

4. 重複 1-3。

4.Repeat 1-3.

圖 8.2

● **次數**

身體升上下震地為一循環，共做七循環。

● **Repetition**

Body uplift and hit floor as 1 cycle, total 7 cycles is required.

第八式 ： 往後七顛百病消
Fifth move : Seven back fall rid illnesses

8

● **動作要點**

1. 身體保持中正，頭顱向上頂，保持平衡。
2. 身體上升時，應感到全身背後至腳跟有伸展及對拉感覺。
3. 腳跟震地時，頸後有微震感覺。

Key points

1.Keep the body centralised, crown of head kept lifted up, maintain balance.

2.When the body raises up, one should feel the whole back to heels has an opposite stretching sensation.

3.When heels impact with floor, occipital should feel light trembling.

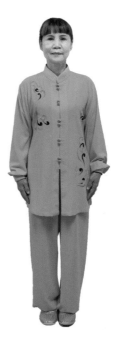

● **易犯錯誤及糾正方法**

X 提身太過至失平衡。

✔ 以頭帶身上升，保持中正。

X 腳跟撞地力太大及閉氣。

✔ 腳跟適量震地，用口舒緩放氣

Common mistakes and correction

X Raise body too much forcelead to lose balance.

✔ Use crown of head to lift body up, maintain centralisation.

X Heel impact to floor too harshly and hold breathe.

✔ Heel make gentle impact on floor , use mouth to gentle exhale.

● **功理與作用**

脊椎為陽氣所在及與五臟六腑有直接聯繫，後顛可刺激陽氣及各臟腑功能以提高免疫力。

● **Benefits**

Spine is the storage of Yang Qi and directly links to all internal organs cavity, the gentle impact of heels to the floor can energise it to stronger immunity.

收式
Closing

⦿ **動作循序 Movement flow**

1. 續上式。 兩臂內旋，向兩側擺起，與髖同高，掌心向後，目視前方。
【圖1、圖2】

1. With the above formula,rotate your arms inward, swing them to both sides at the same height as your hips, palms back, looking forward.

2. 兩臂屈肘，兩掌相疊於丹田處（男性左手在內，女性右手在內），目視前方。
【圖3】

2. Bend the elbows with your arms, and place the palms on top of each other (left hand inside for males and right hand inside for female), looking ahead.

3. 兩臂自然下落，兩掌貼於兩腿外側，目視前方。 【圖4】

3. Fall your arms naturally, and attach your two palms to the outside of your legs, looking forward.

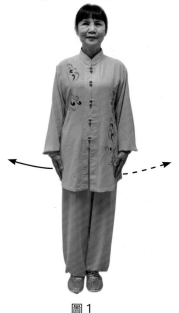

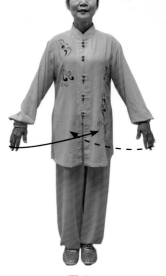

圖1 圖2 圖3

收式
Closing

● **動作要點**

體態安舒，全身放松，呼吸自然，氣沈丹田。

Key points

Make sure that with all the movements, you are fully comfortable, relaxed, breathing naturally, and trying to sink your breath to the Dantian (lower belly).

● **易犯錯誤及糾正方法**

X 收功隨意，動作結束後還心浮氣躁，急於走動。

✔ 收功時要心平氣和，保持呼吸緩慢暢順。

圖4

Common mistakes and correction

X Finishing movements at will, unsettled and restless after the end of the action, impatient and eager to walk around.

✔ When finishing the exercises, be calm and keep breathing slowly and smoothly.

● **功理與作用**

氣息歸元，放松肢體肌肉，愉悅心情，加強和鞏固練功效果。

● **Benefits**

Return breath to the original, relax body muscles, delight mood, strengthen and consolidate the exercise effect.

【太極扇】

武術/廣場舞/表演扇

可訂制LOGO

紅色牡丹

粉色牡丹

黃色牡丹

紫色牡丹

黑色牡丹

藍色牡丹

綠色牡丹

黑色龍鳳

紅色武字

黑色武字

紅色龍鳳

金色龍鳳

純紅色

紅色冷字

紅色功夫扇

紅色太極

打開淘寶天貓APP

掃碼進店

微信掃一掃

進入小程序購買

【專業太極刀劍】

晨練/武術/表演/太極劍

打開淘寶天貓
掃碼進店

手工純銅太極劍

神武合金太極劍

桃木太極劍

平板護手太極劍

手工銅錢太極劍

鏤空太極劍

手工純銅太極劍

神武合金太極劍

劍袋·多種顏色、尺寸選擇

銀色八卦圖伸縮劍

銀色花環圖伸縮劍

龍泉寶刀

棕色八卦圖伸縮劍

紅棕色八卦圖伸縮劍

微信掃一掃
進入小程序購買

【學校學生鞋】

多種款式選擇・男女同款

可定制logo

香港及海外掃碼購買

檢測報告

商品注册證

【武術/表演/比賽/專業太極鞋】

打開淘寶天貓
掃碼進店

微信掃一掃
進入小程序購買

正紅色【升級款】
XF001 正紅

藍色【經典款】
XF8008-2 藍

黃色【經典款】
XF8008-2 黃色

紫色【經典款】
XF8008-2 紫色

正紅色【經典款】
XF8008-2 正紅

黑色【經典款】
XF8008-2 黑

綠色【經典款】
XF8008-2 綠

桔紅色【經典款】
XF8008-2 桔紅

粉色【經典款】
XF8008-2 粉

XF2008B（太極圖）白

XF2008B（太極圖）黑

XF2008-2 白

XF2008-3 黑

5634 白

XF2008-2 黑

【太極羊・專業武術鞋】

兒童款・超纖皮

XF808-1 銀

XF808-1 白

XF808-1 紅

XF808-1 金

XF808-1 藍

XF808-1 黑

XF808-1 粉

短袖款

长袖款

【專業太極服】

多種款式選擇‧男女同款

微信掃一掃
進入小程序購買

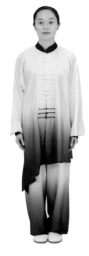

黑白漸變仿綢

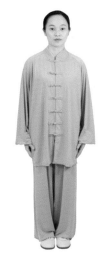

淺棕色牛奶絲

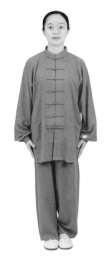

白色星光麻

亞麻淺粉中袖

白色星光麻

真絲綢藍白漸變

【正版教學光盤】

正版教學光盤 太極名師 冷先鋒 DVD包郵

打開淘寶天貓APP
掃碼進店

微信掃一掃
進入小程序購買

香港國際武術總會裁判員、教練員培訓班
常年舉辦培訓

　　香港國際武術總會培訓中心是經過香港政府注册、香港國際武術總會認證的培訓部門。爲傳承中華傳統文化、促進武術運動的開展，加强裁判員、教練員隊伍建設，提高武術裁判員、教練員綜合水平，以進一步規範科學訓練爲目的，選拔、培養更多的作風硬、業務精、技術好的裁判員、教練員團隊。特開展常年培訓，報名人數每達到一定數量，即舉辦培訓班。

報名條件：熱愛武術運動，思想作風正派，敬業精神强，有較高的職業道德，男女不限。

培訓内容：1.規則培訓；2.裁判法；3.技術培訓。考核内容：1.理論、規則考試；2.技術考核；3.實際操作和實踐（安排實際比賽實習）。經考核合格者頒發結業證書。培訓考核優秀者，將會録入香港國際武術總會人才庫，有機會代表參加重大武術比賽，并提供宣傳、推廣平臺。

聯系方式
深圳：13143449091（微信同號）
　　　13352912626（微信同號）
香港：0085298500233（微信同號）

國際武術教練證　　　國際武術裁判證

微信掃一掃
進入小程序

香港國際武術總會第三期裁判、教練培訓班

打開淘寶APP
掃碼進店

【出版各種書籍】

中英文版
English
★★★★

申請書號>設計排版>印刷出品

>市場推廣

港澳台各大書店銷售

冷先鋒

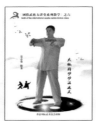

國際健身氣功堂系列教程之一
《八段錦》

總 編 輯：冷先鋒
責任印製：冷修寧
翻　 譯：馬昌華（英國）
版面設計：明栩成

香港先鋒國際集團　審定
太極羊集團　　贊助
香港國際武術總會有限公司　出版
香港聯合書刊物流有限公司　發行
代理商：臺灣白象文化事業有限公司

國際書號：978-988-75078-2-6
香港地址：香港九龍彌敦道 525 -543 號寶寧大廈 C 座 412 室
電話： 00852-98500233 \91267932
深圳地址：深圳市羅湖區紅嶺中路 2118 號建設集團大廈 B 座 20A
電話： 0755-25950376\13352912626
臺灣地址： 401 臺中市東區和平街 228 巷 44 號
電話： 04-22208589
印次： 2021 年 6 月第一次印刷
印數： 5000 冊
網站 :www.hkiwa.com　Email: hkiwa2021@gmail.com
海外網址： www.deyin-taiji.com / www.taichilink.net
Tel： 0044 7779 582940